East Anglian Epitaphs

East Anglian Epitaphs

RAYMOND LAMONT-BROWN

ACORN EDITIONS

Acorn Editions
Fakenham, Norfolk

First published 1980

© R. Lamont-Brown 1980

ISBN 0 906554 02 0

Printed in Great Britain

Contents

Author's Preface

Epitaphs have never failed to amuse, delight and intrigue me, and from my post-bag I can see that they interest hundreds of others. Following the publication of my other five anthologies of epitaphs, dozens of people from East Anglia wrote to me sending epitaphs from Norfolk and Suffolk; some they had seen, others they were enquiring about. Most bemoaned the fact that there was nothing in print for East Anglia about the subject: this book is an attempt to put this right.

Those who record epitaphs are doing the community a great service in terms of local history. Some of the oldest stones are being eroded away quickly, others removed by councils to make grass-cutting easier and yet more fall foul of mindless vandals. Epitaph collecting is a fascinating hobby: one discovers valuable facts about ancestry; emblems and symbols of life and death; and, new and intriguing information about people who lived centuries ago.

East Anglia has a rich collection of epitaphs and the neighbouring counties have epitaphs to East Anglians. Here's one to be found on the north wall of the church at Belchamp Walter, Essex:

> Snug by the Wall lies old SAM COOK
> Who with his Spade, his Bell, and Book
> Serv'd Sexton three Score Years and Three
> Until his Master, grim Death, cry'd
> Enough, your tools now lay aside
> And let a Brother bury thee
>
> Died 6 May 1800, Aged 89 Years

At the Church of St Mary at Mistley, Essex, is the prose and verse epitaph of that notable East Anglian, Thomas Tusser, variously described as 'Old Etonian', 'musician', 'indifferent farmer', but who warranted immortality on this tablet:

> 'Sacred to the Memory of Thomas Tusser, Gent.
> Born at Rivenhall in Essex and occupier of Braham-Hall near this town in the reign of King Edward the Sixth, where he wrote his celebrated poetical treatise entitled "Five Hundred Points of Good Husbandry &c." His writings show that

He possessed a truly Christian spirit, and his excellent maxims, and observations on rural affairs, evince that he was far in advance of the age in which he lived:— He died in London in 1580, at the age of 65, and was interred in the Parish Church of St. Mildred in the Poultry, where the following epitaph said to have been written by himself, recorded his memory:—

Here Thomas Tusser, clad in earth doth lie,
Who sometimes made the Points of Husbandry:
By Him then learn thou may'st—here learn we must,
When all is done, we sleep, and turn to dust:
And yet, through Christ, to Heaven we hope to go,
Who reads his books, shall find his faith was so.'

Sometimes in foreign lands East Anglians beg for attention:

'Sacred to the Memory of DAVID MAY the son of HENRY and LYDIA MAY who lost his life in the Gulf of Florida aboard the *Ann West* Indiaman on the 23 June 1819:

Not yet have ceas'd to flow a Widow's tears
O'er scenes remembered amidst the lapse of years
On foreign Seas he fell, but not by storm
When boist'rous winds the heaving waves deform
Nor by the Rock beneath the tide conceal'd
Nor by the Sword which warring nations wield
But by the foe receiv'd in Friendship's guise
By hands of treach'rous Pirates Lo he dies
Thou, too, art mortal hast'ning to the grave
Believe on him who ever lives to save

These lines are inscribed by his Widow as the last Melancholy tribute of Affection.'

The reverse is also true—Essex men in Suffolk, for instance: to John Daniell, formerly of Messing, Essex, d. August 1584, in the chancel of Wetherden Church, Suffolk:

Here lye the bones now rotten
Of one not forgotten
For his vertue none should dye
In a worthie memorie
Who from noblye gentle
Yeelded fruite most sweetlye good
And despising worldly pelf
Did but heavenlye love himself

The secret writings of Norfolk and Suffolk are almost down every byway. On fireplaces and walls, statues and fences, gable-ends and chimney-pots are the scratchings of men and women down the centuries who passed that way. Here are lovers' initials on a gate-post, there are a mason's marks upon a monument, all telling a forgotten personal story in secret writing. By far the most loquacious secret writings are those in the churchyards of Norfolk and Suffolk.

The art of the epitaph is, alas, nearly dead in Britain, where it once flourised as an art form. At its very finest it demanded considerable ability and high artistic skill, as well as, of course, the best intentions. Where these were not present the result was liable to be ridiculous or cynical.

In its heyday it led, often, to great length of eulogy until an early writer was moved to protest against what he called:

> '. . . long and tedious discourses hanged up in churches and chancels over the tombs of great men and others, which be so exceeding long as one must have halfe a dayes leisure to reade one of them, and must be called away before he halfe come to the end, or else be locked into the church by the Sexten in a certain cathedral church of England.'

At the other extreme it led to well chosen brevity like the tomb in Westminster Abbey which bears the four words: O RARE BEN JONSON.

Between those two extremes were the often astonishing churchyard witticisms and criticisms, puns and lampoons which are the flesh and blood of this book.

<div align="right">

RAYMOND LAMONT-BROWN
St. Andrews, 1980

</div>

Important Note

All the epitaphs which appear in this book are genuine and authentic, in that they all once embellished the graves or tombs of the deceased in East Anglia. As time passes, alas, many of the epitaphs become less and less accessible.

Vandalism, weather, rural and urban decay, or church renovation—and several other reasons—may make it that several of the epitaphs herein quoted have been moved from their original sitings. So, the collector should not be surprised nor disappointed if they are not to be found where latterly cited. Where no site is given, the exact whereabouts of the epitaph is not known today.

Looking at East Anglian Church Monuments

Epitaphs are the inseparable bedfellows of the church funerary monument. The earliest tombs with their epitaphs to be found in parish churches in East Anglia are those of the twelfth century. Most of them are simple stone slabs which have been removed in their hundreds by countless decades of vandals, municipal and deranged. During the Romanesque period burials inside churches were mainly reserved for ecclesiastics and religious dignitaries. Recent excavation has shown us that the close kinfolk of clerics could be buried in a (unmarked) grave inside the church.

By the thirteenth century, the recumbent effigy had become popular. These tombs with their simple Latin epitaphs, tell us a great deal about the fashions and customs of the times. By the fourteenth century, however, the richly carved stone canopy had made its debut. Usually the material for the monuments was alabaster, stone, Purbeck marble (during the earlier medieval period), wood or bronze.

Today there are no bronze funerary effigies in East Anglia, but these wooden ones are of note:

Fersfield, Norfolk: The coloured effigy to Sir Robert de Bois, 1311.

Boxted, Suffolk: To William Poley and wife, 1587.

Wingfield, Suffolk: To Michael de la Pole, Earl of Suffolk, and wife, 1415.

Pre-reformation epitaphs were usually in the form of tender prayers both for the living and the dead. During this time the epitaph sentiment was closely reflected in the surrounding symbolism of the tomb. Around the sides of many a medieval tomb are the little figures called 'weepers'. These are not to be confused with the figures representing the deceased's children: 'weepers' are the mourners or intercessors for the souls of the departed. These figures may be bedesmen (i.e. a hired mourner), or old men and women who received alms from their now dead benefactor (See the examples at *Reepham, Norfolk*). Usually the medieval carved funerary effigies in East Anglia are in humble recumbent attitudes, with hands clasped in eternal prayer. Of this period these tombs are of note:

1

Ashwellthorpe, Norfolk: Sir Edmund de Thorpe and wife, 1417.

Dennington, Suffolk: Note the eagle and griffin at the feet of Lord Bardolph and wife, 1441.

Hawstead, Suffolk: Cross-legged knight, 1270.

Wingfield, Suffolk: Sir John Wingfield, 1361. John de la Pole, Duke of Suffolk, Knight of the Garter and wife, 1491.

Elizabethan epitaphs most often dwelt on what people did in life. Certainly in Tudor times rich merchants commemorated themselves with sumptuous monuments. Post-Reformation times brought a change in effigy attitudes, instead of exclusively devotional recumbent figures there were more 'lolling' effigies. By the sixteenth and seventeenth centuries more figures were shown kneeling. Here are some typical Tudor monuments from *Fakenham, Suffolk:*

Henry Fitzroy, Duke of Richmond, 1536. Note how his 'epitaph' is stories from *Genesis.* See too the Shields with Instruments of the Passion.
Thomas Howard, Duke of Norfolk and wife, 1554. Apostles.
Two wives of the Duke of Norfolk, 1557 and 1564. See the statued 'animal epitaph' with pony, dog, stag and dragon.

Jacobean epitaphs were more often historical, but still described what people did. Seventeenth-century monuments tend to be huge, lavishly coloured and resplendent in armorials. A child figure holding a skull shows that it died before the main inhabitant of the tomb: there is such a monument at *Besthorpe, Norfolk,* to Sir William Drury and family, 1639.

There are many monuments in Suffolk representing Jacobean times, but perhaps these are the best:

Bramfield: Arthur Coke and wife, 1629. A fine example of sculpture of the period. Note the ledger stone epitaph nearby recording what happens when one decides to marry twice.

Culford: Lady Jane Bacon, 1654.

Framlingham: Henry Howard, Earl of Surrey, 1614.

Helmingham: The Tollemarche tomb of 1550-1605. Note the very lengthy epitaph.

From 1600 to the Civil War, epitaphs were poetic, changing to inscriptions of one line, or one phrase, under Oliver Cromwell. During the period 1660-80 epitaphs became very long-winded and pompous. Black and white marble superseded alabaster by the 1690's and colouring effigies ceased. Sculpture, however, became more and more stupendous. Have a look particularly at these monuments from Suffolk of that date:

Boxted: Sir John Poley, circa 1690. Dame Abigale Poley, 1725. This is said to be the last alabaster funerary monument made in England.

Redgrave: Sir John Holt, Lord Chief Justice, 1710.

By and large the wit and wisdom of the epitaph outgrew the sculptural flamboyance of the tomb. As lavishness declined the epitaph prospered, so that the era 1700-80 was the heyday of the wicked, lampooning epitaph.

Shades of the Legions

Roman East Anglia was the home of two great tribes, the Iceni and the Trinovantes, who inhabited the north and south respectively. If it were not for Roman epitaphs found in East Anglia our knowledge of these peoples would be very much less. Roman tombstones tell us of the great Icenian Queen Boudicca, and how envoys from the Trinovantes approached Caesar to deliver them from the mighty Belgic king Cassivellaunus: All this, as well as giving us priceless data about the people who lived in East Anglia in Roman times.

The great centres of Roman society in East Anglia were undoubtedly *Branodunum* (Brancaster), *Venta Icenorum* (Caistor St Edmund), *Gariannonum* (Burgh Castle) and the site which overshadows them all, *Camulodunum* (Colchester). It is in these areas that one would expect to find epitaphs of East Anglian relevance in Roman times; or, along the roadsides which radiated from the sites. Burials were not allowed within a Roman township, so the roadsides leading out of a city were usually strewn with graves.

Most Roman epitaphs to be found in East Anglia begin with D.M., or D.M.S.—*Dis Manibus,* or *Dis Manibus Sacrum*—'dedicated to the souls of the departed', or *Siste (Aspice) Victor,*—'Stop, passer-by', or *Sit tibi terra levis*'May the earth be light upon thee'.

In 1764 there was found, on the site of a Roman cemetery at Colchester (i.e., south-west of Roman Colchester), this dedication epitaph (alas now lost):

> NUMINIB(US) AUG(USTORUM) ET MERCU(RIO) DEO
> ANDESCOCIUOUCO IMILICO AESURILINI LIBERTUS ARAM OPERE
> MARONIO D(E) S(UO) D(EDIT)
>
> 'To the Deities of the Emperors and to the god Mercury Andescociuoucus, Imilico, freedman of Aesurilinus, from his own resources gave this altar in marble.'

To the east of Beverley Road, and south of Lexden Road, in the Roman burial area to the west of Colchester, was found in 1868 this tombstone:

> M(ARCUS) FAUONI(US) M(ARCI) F(ILIUS) POL(LIA TRIBU) FACILIS

4

C(ENTURIO) LEG(IONIS) XX : VERECUNDUS ET NOUICIUS LIB(ERTI) POSUERUNT: H(IC) S(ITUS) E(ST)

'Marcus Favionius Facilis, son of Marcus of the Pollian voting-tribe, centurion of the Twentieth Legion, lies buried here; Verecundus and Novicius, his freedmen, set this up'.

Lying on its face, near the south-western gate of Roman Colchester, was this famous epitaph of a Roman cavalryman. It is now in Colchester museum:

LONGINUS SDAPEZEMATYGI F(ILIUS) DUPLICARIUS ALA PRIMA TRACUM PAGO SARDI(CA) ANNO(RUM) XL AEROR(UM) XV HEREDES EXS TESTAM(ENTO) F(ACIENDUM) C(URAUERUNT) H(IC) S(ITUS) E(ST).

'Longinus, son of Sdapezematygus, (esteemed soldier—that is he received double wages for some act of bravery) from the First Cavalry Regiment of Thracians, from the district of Sardica, aged 40, of 15 years service, lies buried here; his heirs under his will had this set up.'

Sometimes Roman tombstones were surmounted by funerary statues, such would probably be the one from Martlesham, Suffolk, now in the British Museum:

DEO MARTI COROTIACO SIMPLICIA POSEU(OTUM) P(OSUIT) L(IBENS) M(ERITO)—GLAUCUS FECIT

'To Mars Corotiacus Simplicia for herself willingly and deservedly set up this offering—Glaucus made it.'

Many pieces of Roman epitaphs have been found by chance in East Anglian fields (turned up by the plough), or set into walls as fillers, or facing stones. They make fascinating and important finds for the epitaph hunter.

Grave Thoughts in Brass

In ecclesiastical terms, a 'brass' is a monument in the form of thin, engraved brass (alloy) plate indented into stone or marble slabbing. The countersunk design in the stone often survives when the brass has been stolen.

The epitaphs connected with the earliest of the brasses, which date from the thirteenth century were in Norman French and were set in the style known as Lombardic letters. From the 1350's, the inscriptions were set out on brass strips, mostly in Latin. The most common of the Latin epitaphs would be:

> *Cujus animae propicietur deus, amen*
> ('May God have mercy on his soul')

Such epitaphs are subject to much abbreviation: In this case the shortening would be:

> *Cui.aie.ppict'.ds.Am.*

The first use of English for a brass epitaph was in 1393. (Brass to Sir Thomas Walch and wife at Wanlip Church, Leicestershire).

East Anglia has a rich heritage of brasses. Those worthy of note for style and content are at: *Acton, Suffolk* (Sir Robert de Bures, *circa* 1310); *Gorleston, Norfolk* (Sir Adam de Bacon, *circa* 1320); *Elsing, Norfolk* (Sir Hugh Hastings, 1347); *Easton, Suffolk* (Mrs Radcliff Wingfield, 1601); *Yoxford, Suffolk* (Tomasine Tendring, 1485); and, *Letheringham, Suffolk* (Sir John de Wingfield, 1389).

The most common epitaph on brass in East Anglia reads:

> *Quisquis eris qui transieris*
> *Sta, perlege, plora.*
> *Sum quod eris, fueramque quod es;*
> *Pro me, precor, ora.*

Mirrored in many a graveyard as:

> Whoever ye be that passes by,
> Stop here, and read, and breathe a sigh.
> Look such as we are, such shall ye be,
> And such as we were, such be ye.

6

Another addressed to the reader is:

> *Vermibus ut donor sic hic ostendere conor*
> *Et sicut hic ponor ponitur omnis honor.*
> *Hinc tu qui transis magnus medius puer an sis*
> *Pro me funde preces ut sit mihi veniae spes.*

> Here I am given to worms as here I attempt to show,
> And down this path to the grave every honour must go.
> You who pass by the way, whether aged or upright or boy,
> Pour out prayers for me that I may have hope of joy.

The most common epitaph prayers are to the Virgin Mary:

> *O virgo virginum, ora pro nobis tuum filium.*
> ('O Virgin of Virgins, pray to your Son for us').

But some saints are addressed direct:

> *Me precor Amphibale salvans ad sidera sume.*
> ('Amphibalus, I pray, save me and lift me on high').

Brass epitaphs often contain favourite quotations from the Bible: One seen
often in East Anglia comes from *Job*, xix, 25-7:

> *Credo quod Redemptor meus vivit, et in novissimo die de Terra surrecturus sum, et*
> *rursum circumdabor pelle mea Et in carne mea videbo Deum salvatorem meum; Haec*
> *spes reposita est in sinu meo.*

> ('For I know that my redeemer liveth, and that he shall stand at the latter day
> upon the earth: and though after my skin worms destroy this body, yet in my
> flesh shall I see God: whom I shall see for myself and mine eyes shall behold, and
> not another; though my reins be consumed within me.')

Several epitaphs on brass complain bitterly of the snatch of death. Here's
one seen (at one time) in several sites in East Anglia:

> *Filiolus, coniux, pater effera fata queruntur*
> *Quae dilectam () eripuere marito*
> *Et primogenitam () : velut altera phaenix*
> *Dum parit illa perit, dum parturit interit ()*
> *() anima e coelo, lustris iam quinque peractis*
> *In coelam redijt, sed terrae huic ossa reliquit.*

> Husband and father and son complain of the fierceness of fate
> Fate which has snatched () away from the love of her mate,
> And too her eldest child (); for she like a Phoenix returned
> Bringing to birth came to death; () while giving life, death discerned
> Five times five had the years rolled by when (), who from God
> Gained her soul now gave it back but left her bones under this sod.

Those who are interested in Latin epitaphs, as seen on East Anglian brasses,
and who have difficulty in translating them, I would call their attention to a
translation aid which appears on pages 22-4 of my book *A Book of Epitaphs*

(Pub: David & Charles, 1967). To this may be added the following which might cause difficulty:

DNS, or DNI; *Dominus, Domini:* Lord
OR' P'AIA: *Orate pro anima:* Pray for the Soul (of . . .)
HUJ ECCLI'E: *Huius ecclesiae:* (Of) this church
JHS, or JHU: *Jhesus:* Jesus
POS.P: *Posuit:* Placed
MP: *Morens posuit:* Sorrowfully placed
HSJ, or HSE: *Hic sepultus jacet* (or *est*): Here is buried . . .
MS: *Memoriae sacrum:* Sacred to the memory (of . . .)

Remember too, that *miles* is knight, *comes* is earl, *armiger* is esquire, *generosus* is gentleman, *mercator* is merchant, and *sacerdos* is priest.

Sometimes the date of an epitaph, in itself, gives rise to puzzlement. For example:

MD DEMETUR X OCTO XPI RUIT ANNUS

'Fifteen hundred, take away eighteen runs the year of Christ'—i.e. an academic joke for 1482.

Or:

APRILIS DENO LUCE CESSIT AB HAC QUE KALENDAS ANNO MILLENO QUATUOR CENT' BIS QUAT' ADDAS X

'(He) departed from this light on the tenth day before the Kalends (i.e. New Moon) of April in the year one thousand four hundred add twice four times ten' (i.e. 23 March 1480).

A typical example of rustic verse on brass occurs at *Aldeburgh, Suffolk:*

To you that lyfe posses great troubles do befall
When we that sleepe by Death do feele no harme at all.
An honest life dothe bringe A joyfull Deathe at last,
And Life agayne begins when Deathe is over past.
My lovinge Foxe farewell God mayde the wt his grace
Prepare thyselfe to come And I will give the place
My children all adewe And be right sure of this
You shall be brought to Dust As Emme Foxe yo'r Mother is.

It is likely that the shortest complete inscription in brass is that from *Acton, near Long Melford, Suffolk:* It reads IOHANNES DANIEL.

At *Mulbarton, Nr. Norwich,* are more metaphysical lines:

Dear love, one Feather'd minute & I come
To lye down in thy darke Retireing Roome
And mingle dust with Thine; yt wee may have
As when alive one bed, so dead one grave.
And may my Soul teare through the vaulted sky
To be with thine to all Eternity.
O How our Bloudless formes will yt day greet

With Love Divine when we again shall meet
Devest of all Contagion of the Flesh
Fulfill'd with everlasting joys & Fresh
In Heaven above, And ('t may be) cast an eye
How far Elizium doth beneath us lye.
Deare, I disbody and away
More Swift than Wind
Or Flying Hind.
I come, I come away.

Played on Words

To Matthew Mudd

St Mary, West Walton, Norfolk.

> Here lies Matthew Mudd.
> Death did him no hurt.
> When alive, he was but Mudd,
> And now dead, he's but dirt.

Curious Brevity

St Mary, Thornham Parva, Suffolk.

> To MARGARET, the wife of
> HUGH WRIGHT.
> (Eye) findeth; (Heart) chooseth; (Knot) bindeth; (Death) Looseth.

On William Willing

Holy Trinity, Long Melford, Suffolk.

> Death will'd that WILLING here should lie,
> Although unwilling he to die.

A Smuggler

Holy Trinity, Blythburgh, Suffolk.

> Here I lies
> Kill'd by the XIS.

N.B.: This is a common epitaph in Great Britain.

Eye-strain with Reed-ing

St Andrew, Westhall, Suffolk.

> Reader of these four lines take heed,
> And mend your life for my sake:
> For you must die, like ISAAC REED,
> Tho' you *read* till your eyes ache!

Buns and Guns

St John the Baptist, Needham Market, Suffolk.

> Here lies John Bun
> He was killed by a gun.
> His name was not Bun but Wood,
> But Wood would not rhyme with Gun,
> But Gun would.

To Frederick Twitchell

St Peter and St Paul, Fressingfield, Suffolk.

> Dep June 11. 1811.
> Aged 24 yrs, 5 mos.
> Here lies the bones of Lazy Fred,
> Who wasted precious time in bed.
> Some plaster fell down on his head,
> And thanks be praised—Our Freddie's dead.

N.B.: Epitaph collected by the Rev. A. L. Macock in *Such Things Happen* (1903). Stone seems now to have been removed.

Another Fred

The same collector of the above averred that this came from St Botolph, Trunch, Norfolk.

> Here lies Fred, who was alive, and is dead.
> Had it been his father, I had much rather:
> Had it been his mother, better than another:
> Had it been his sister, no one would have missed her:
> Had it been his entire generation,
> So much better for the nation:
> But since 'tis Fred, who was alive, and is dead,
> There's no more to be said.

11

The Epitaph of Charles Knight

All Saints, Walsoken, Norfolk.
 Good Knight.

One plus One makes?

Dunstan Churchyard, Norfolk.

> Here lies a noble pair, who were in name,
> In heart and mind and sentiments the same.
> The arithmetic rule then can't be true:
> For one and one did never here make two.

Lord Remember a Printer

At Bury St Edmunds, Suffolk, recorded by E. Goldsmid:

> Here lie the remains of L. Gedge, Printer
> Like a worn-out character, he has returned to the Founder.
> Hoping that he will be recast in a better and more perfect mould.

Encased in Wood

Woodton Burial Ground, Norfolk.

> Here lies John Rackett
> In his wooden jacket;
> He kept neither horses nor mules.
> He lived like a hog,
> And died like a dog,
> And left all his money to fools.

One alone at last; one Obit 1690

St John, Maddermarket, Norwich, Norfolk. Recorded by the Rev. Edward L. Cutts, D.D. (1898):

> Here snug in her grave my wife doth lie,
> Now she's at rest and so am I!

> Here lie the bones
> Of JOSEPH JONES,
> Who ate whilst he was able:
> But, once o'erfed,
> He dropped down dead,
> And fell beneath the table.

When from this tomb,
To meet his doom
He rises amidst sinners;
Since he must dwell
In Heaven or Hell.
To take him, which gives best dinners.

N.B.: *Obit* means, '(He) died'.

Thos Aid and his Wife Ann

Ketteringham Church, Norfolk.

> 1664 and 1665
> She He

Here TWO in ONE at rest reposed be,
In expectation of the ONE in THREE.

Before your very Ies!

St Mary, Bury St Edmunds, Suffolk.

He that will sadly behold me with his ie,
JOHN Maye see his ow Merowr and lerne to die. BARET.

One MORE of Norwich

At Ellingham, near Bungay, Suffolk.

More had I one, More would I have,
More is not to be had;
The first I . . . the next is vaine
The third is too too bad.

If I had us'd with more regard,
The More that I did give,
I might have made More use and fruit
Of More while he did live.

But time will be recal'd no more,
More since are gone in briefe
Too late repentance yields no More,
Save only paine and griefe.

My comfort is, that God hath More
Such Mores to send at will,
I hope whereof I sigh no more,
But rest upon him still.

John Warner Obit 1641. Aet 92

St Mary Key, Ipswich, Suffolk.

> I WARNER once was to myself
> Now Warning am to thee
> Both living, dying dead I was.
> See, then, thou warned be.

N.B.: *Aet* short for *Aetas,* 'years of age'.

At the same churchyard is this stone to William Haselwood, Obit 1643, *Aet 3:*

> The Hasel nut oft children crops
> God HASELWOOD in Childhood lopps
> Then, Parent, yield, God says, hee's mine,
> And took him hence, say not hee's thine.

Mary Cleere, too is celebrated here. Obit 1618.

> CLEERE was my name, my life was also clear,
> Like name, like life, for I the light did love.
> Earst that this life I left this did appear
> Even unto men as unto God above;
> Remit who did my sins, my fears remove,
> Ere yet he called my soul to Christ my love.

Daniel Lalthow of Norwich

Obit 1614. *Aet* 29.

> Whose Vertues cause him live, tho' hee,
> From Mortall Eyes, here hidden bee.

All-in

In Hadleigh Church, Suffolk.

> The Charnel mounted on this w ⎫
> Sets to be seen in funer ⎪
> A matron playn domestic ⎪
> In housewifery a princip ⎪
> In care and payns continu ⎪
> Not slow, nor gay, nor prodig ⎬ all
> Yet neighbourly and hospit ⎪
> Her children seven yet living ⎪
> Her sixty-seventh year hence did c ⎪
> To rest her body natur ⎪
> In hope to rise spiritu ⎭
> ELLEN, wife of ROBERT RESON, Alderman of this town.
> Shee deceased January 8th, 1539, and is interred below hereby.

14

Lambe's Words

In East Bergholt Church, Suffolk.

Edward	EDWARD LAMBE,	Lambe
Ever	second sonne of	Lived
Envied	Thomas Lambe,	Laudably
Evill	of Trimley,	Lord
Endured	Esquire	Lett
Extremities	All his days	Like
Even	he lived a Bachelor	Life
Earnestly	Well learned in Deveyne	Learne
Expecting	and Common Lawes,	Ledede
Eternal	with his councell he	Livers
Ease	helped many, yett took	Lament
	fees scarse of any.	

He dyed the 19th November, 1647.

Knott in

Epitaph for Mr. Knott, a parishioner of St Peter Mancroft, Norwich, Norfolk.

Here lies a man who was Knott born;
His father was Knott before him.
He lived Knott, and he did Knott die,
Yet underneath this stone doth lie.
Knott christened, Knott begot.
And here lies, and yet was Knott.

A Farmer's Daughter

Lettice from Stowlangtoft, Suffolk.

Grim death, to please his liquorish palate
Has taken my Lettice to put in his sallat.

Doubtful Names

From a stone once reputed to be at Bury St Edmunds, Suffolk:

Here lies Johnathan Yeast
Pardon him for not rising.

15

Gentlemen and Scholars

On a Coroner

St Margaret, Cley-next-the-Sea, Norfolk.

> He lived and died
> By suicide.

A Lost Body

St Catherine, Ludham, Norfolk.

> Underneath this sod lies JOHN ROUND,
> Who was lost at sea and never found.

N.B.: These words do occur in other parts of the country!

Hail to the Parson!

St Peter and St Paul, Lavenham, Suffolk.

> Hurrah! my boys, at the Parson's fall,
> For if he lived he'd buried us all.

Bones into Hay

St Mary, Woodbridge, Suffolk.

> Beneath the gravel and these stones,
> Lie poor JACK TIFFEY'S skin and bones;
> His flesh, I often heard him say,
> He hoped in time would make good hay;
> Quoth I, 'How can that come to pass?'
> And he replied, 'All flesh is grass'.

John Adams and Bump

St Mary, Dennington, Suffolk.

> Here lies JOHN ADAMS, who received a thump,
> Right on the forehead, from the parish pump,
> Which gave him the quietus in the end
> For many doctors did his case attend.

N.B.: *Quietus* or *quietus est* was a formula used in discharging accounts, i.e. marking 'paid'. So John Adams was 'paid off' by death.

While you are here, go into the church and have a look at the fine alabaster effigies of Lord and Lady Bardolph (1441).

Johnathan Gill, d. Feb 6 1751

St Mary, Ufford, Suffolk.

> Beneath this smooth stone,
> By the bone of his bone,
> Sleeps Mr Johnathan Gill,
> By lies when alive this
> Attorney did thrive,
> And now that he's dead—he lies still.

Penned by himself

St Peter and St Paul, Kedington, Suffolk.

> Here lies John So,
> (So so did he so),
> So did he live,
> So did he die,
> So so did he so,
> So let him die.

N.B.: Another who exists in the sleep of death here, but this time inside the church, is Grissel Barnardiston, spinster who died in 1609. Her effigy is unusual in that it kneels not lies.

A Clergyman

Norwich, Norfolk.

> JOHN KNAPTON
> Under this Ston
> Ligs John Knapton
> Who died just

The Twenty eight of August
MXC and on,
Of this Church peti-canon.

A Highwayman

Nayland Churchyard, Suffolk.

> Here sleepeth in dust,
> NED ALSTON,
> The notorious Essex Highwayman,
> Ob. Anno Dom. 1760.
> AEtat 40.

My friend, here I am—Death at last has prevail'd
And for once all my projects are baffled,
'Tis a blessing to know, tho', when once a man's nail'd
He has no further dread of the scaffold,
My life was cut short by a shot thro' the head,
On his Majesty's highway at Dalston—
So as now 'Number One's numbered one of the dead,
All's one if he's Alston or All-stone.

A Curious Desire

Wroxham Churchyard, Norfolk.

> RICHARD KENDRICK was buried August 29th, 1785, by
> THE DESIRE OF HIS WIFE MARGARET KENDRICK.

On William Symons

Woodditton, and at Thorpe St Andrew, Norfolk. On a gravestone in which is
fixed an iron dish, according to the instructions of the deceased:

Here lies my corpse, who was the man
That loved a sop in the dripping pan;
But now, believe me, I am dead,
See how the pan stands at my head.
Still for the sops till the last I cried,
But could not eat, and so I died.
My neighbours, they perhaps will laugh
When they do read my epitaph.

Untimely End

Norwich, Norfolk.

On Jonathan Lewes, who died through a fall from his horse, April 7th 1804, aged 32 years:

> Judge me not, reader; Christ is judge of all:
> I fell—stand'st thou? take warning by my fall;
> Be ready, lest thee sudden death surprise,
> And hence to witnesses against thee rise.

A Soldier

Bury St Edmunds, Suffolk.

> WILLIAM MIDDLEDITCH,
> Late serjeant-Major of the Grenadier-Guards,
> Died Nov. 13, 1834, aged 53 years.

> A husband, father, comrade, friend sincere,
> A British soldier brave, lies buried here.
> In Spain and Flushing, and at Waterloo,
> He fought to guard our country from the foe;
> His comrades, Britons, who survive him say,
> He acted nobly on that glorious day.

Another Soldier

Martham, Norfolk.

> Though shot and shell around flew fast
> On Balaclava's plain,
> Unscathed he passed to fall at last,
> Run over by a train.

Simply a Clerk

Cantley, Norfolk.

> Here lies interr'd
> Beneath these stones
> The beard, the flesh, and eke ye bones
> Of Cantley's clerk, old DANIEL JONES.

19

A Gentlemen from Cantley

Here lieth ye body of ROBERT GILBERT
of Cantley in ye County of Norfolk, Gent.,
who died 5th of October, 1714,
Aged 53 years.

In wise Frugality, LUXURIANT,
In Justice, and good acts, EXTRAVAGANT,
To all ye world a UNIVERSAL FRIEND,
No foe to any, but ye Savage Kind,
How many fair Estates have been Erased
By ye same generous means, yet his Encreased
His duty thus performed to Heaven and Earth
Each leisure hour fresh toilsome sport gave birth!
Has NIMROD seen, he would ye game decline,
To GILBERT mighty hunter's name resign.
Tho' hundreds to ye ground he oft have Chased,
That subtile FOX, DEATH earth him at last,
And left a Fragment Scent, so sewwt behind,
That ought to be persued, by all mankind.

A Fishmonger

St Stephen, Ipswich, Suffolk.

A Solemne Sacred to The
Memory of
ROBERT LEMAN (The sonne of William Leman)

Late of Beckles in the Covnty of Svf: Gent.
And free of Worl. Company of Fishmongers London;
of which city he was chosen sheriffe;
and of MARY his wife,
the eldest davghter of William Gore, of Broome Hall
in the covnty of Northfol; Esq.
Who as in life they were irreprovable
so in death inseparable, both expiring in one day
being the 3rd of Septem: 1637
the same sonne that closed her eyes in the morining
shutting up his in the evening.
They left behind them
1 sonne 4 daughters

Beneath this movement into mbed lye
The rare remark of a conivgall tye.
Robert and Mary who to shew how neere
One loath behind the other long to sat
(As married) dyed together in one day.

A Midwife

From the Old Mens Hospital, Norwich, Norfolk.

> In memory of MRS PHEBE CREWE
> Who died May 28, 1817,
> Aged 77 years.
> Who during forty years
> Practiced as a midwife
> In this city, and brought into
> The world nine thousand
> Seven hundred and
> Thirty children.

A Lawyer

Rineton Churchyard, Norfolk.

> God works a wonder now and then,
> He, though a lawyer, was an honest man.

A Gentle Parson

At Alderton, Suffolk, Rev. Robert Biggs, forty years rector, d.1769.

> HE WAS NOT DISTINGUISHED FOR HIS ACTIVITY
> OR LITERARY ABILITIES. BUT HE WAS WHAT IS
> MORE TRULY VALUABLE—AN HONEST MAN.

Thomas All, Farmer

Alderford, Norfolk, famous for its font of the seven sacraments:

> Reader, beneath this marble lies
> ALL, that was noble, good and wise;
> ALL, that once was formed on earth,
> ALL, that was of mortal birth;
> ALL, that liv'd above the ground,
> May within this grave be found:
> If you have lost or great or small,
> Come here and weep, for here lies ALL;
> Then smile at death, enjoy your mirth,
> Since God has took his ALL from earth.

A Scholar's Grave

The epitaph—OFT COMETH DEATH AMONG MEN/THOUGH A

MAN BE IN GOOD POINT AT EVE/IT CAN HAPPEN THAT HE BE
DEAD BY MORROW—appeared in several churchyards in East Anglia. The
theme that death was no respecter of class or creed was a dominant one in the
fourteenth and fifteenth centuries. At Sparham, Norfolk, is a painted panel
symbolising the theme, and one tomb to a scholar mirrored the sentiment:

> Short and uncertain is the life of man,
> His life's a vapour, and his time's a span,
> His days alas! are swifter than a post,
> He passes by, and in the grave is lost.

Judgement on the Rich

Wymondham, Norfolk; look at the reredos (the ornament behind the altar)
here with its fine Crucifixion motif:

> JOSIAH PERKINS

> A man of wealth and fame
> Of honour and of worth;
> How powerful was his name
> When living on the earth.

> But now he's left the world
> Where riches draw a line
> Distinguishing a man
> From others of his kine.

> What now can this man do
> With what he had whilst here?
> Not aught, for what he had—
> In heaven it can't appear.

> We speak of him 'in heaven',
> Well, let us hope he's there;
> Though the chances of such men
> To get there are but rare.

A Warm Title

Ampton, Suffolk.

> WILLIAM PEPPER

> Tho' hot my name, yet mild my nature,
> I bore good will to every creature;
> I brewed good ale and sold it too,
> And unto each I gave his due.

Written by a Famous Man

This epitaph was written by Alexander Pope (1688-1744), the celebrated poet and translator of Homer, for one John Knight, who is buried at Gosfield Churchyard, Essex. It was noted by the Rev. John Stone in a footnote of his monograph (1878) on Rood Screens, as being the lines on the tomb of another John Knight of Woolpit, Suffolk.

> O fairest pattern to a falling age,
> Whose public virtue knew no party rage,
> Whose private name all titles recommend,
> The pious son, fond husband, faithful friend;
> In manners plain, in sense alone refined,
> Good without show, and without weakness kind;
> To reason's equal dictates ever true,
> Calm to resolve and constant to pursue;
> In life, with every social gift adorned,
> In death, by friendship, honour, virtue, mourned.

Hinc illae lachrymae

('Hence those tears', Horace.) On the last resting place of a 'gentlemanly dog' once owned by a Vicar of Anlingham, Norfolk:

> Thou who passest on the path,
> If haply thou dost mark this monument,
> Laugh not, I pray thee.
> Though it is a dog's grave; tears fell for me,
> And the dust was heaped above me by a master's hands,
> Who likewise engraved these words upon my tomb.

A Sorrowful Quintet

From Wiveton, Norfolk.

> Here lies John and Sarah, Peter and Martha and Mary too,
> They were quins, see what God can do,
> First died ye daughters, then ye sonnes,
> Three days between them every one.

A well-used Epitaph

From Skegness to Felixstowe, this epitaph appears several times set up for sea captains:

> Here we lie in a horizontal position
> Like a ship laid up,
> Stripped of her sails and rigging.

One example remains for the wife of a sea captain:

Unveil, thy bosom faithful tomb,
Take this new treasure to thy trust,
And give these sacred relics room
We'd rather that you did than us.

Tricksters All

Thomas Parr

Swaffham, Norfolk.

> Here lies the body of Thomas Parr.
> What, Old Tom? No.
> What, Young Tom? Ah.

N.B.: While you are here have a look at the angel-churchyard memorial to Susan Blythe, 1854.

Caught at Last!

Holy Trinity, Ingham, Norfolk.

> Here lies an honest independent man.
> Boast more, ye great ones, if ye can.
> I have been kicked by bull and ram;
> Now let me lie, contented, as I am.

N.B.: In the church is the unusual 'waking effigy' of Sir Oliver de Ingham who died in 1344.

On John Hill

All Saints, Icklingham, Suffolk.

> Here lies JOHN HILL,
> A man of skill,
> Whose age was five times ten:
> He never did good
> And never would
> If he lived as long again.*

*N.B.: The alternative of these lines from Norfolk (see page 30).

Fooled 'em All

St Helen, Ranworth, Norfolk.

> Grim death took me without any warning,
> I was well at night,
> And dead at nine in the morning.

The Virtuous and Unvirtuous

Within the railed churchyard of St Mary's, not far from the Norman gateway to the Benedictine Bury St Edmund's Abbey, Suffolk, are these two stones, which in virtue cancel themselves out.

> Reader
> Pause at this Humble Stone
> it Records
> The fall of unguarded Youth
> By the allurements of vice,
> and the treacherous snares
> of Seduction;
>
> SARAH LLOYD
> on the 23rd of April 1800,
> in the 22nd Year of her Age,
> Suffered a Just but ignominious
> Death,
> for admitting her abandoned seducer
> into the Dwelling House of
> her Mistress
> in the Night of 3d Octr.
> 1799
> and becoming the Instrument
> in his Hands of the crimes
> of Robbery and House-burning.
> These were her last Words,
> "May my example be a warning to Thousands".

> Here lies Interred the Body of
> MARY HASELTON
> A Young Maiden of this Town,
> Born of Roman Catholic Parents,
> and Virtuously brought up;
> Who being in the Act of Prayer,
> Repeating Her Vespers,
> was instantaneously killed by a flash
> Of lightening August 16th, 1785,
> Aged 9 years.

Not Siloam's ruinous tower the Victims slew
Because above the many sinn'd the few:
Nor here the fated lightning wreak'd its rage
By Vengeance sent for crimes matur'd by age
For whilst the Thunder's awful voice was heard
The little Suppliant with its hands uprear's
Address'd her God in prayer the Priest had
taught
His mercy crav'd, and his protection sought
Learn Reader hence, that Wisdom to adore
Thou can'st not scan; and fear his boundless
Power
Safe shalt thou be, if thou perform'st his will
Blest if he spares, and more blest should he kill.

A Waggoner Sly

John Catchpole of Palgrave, Suffolk, had an eye for a profitable deal: he died
16th July 1787, aged 75 years:

My horfes have done Running,
My Waggon is decay'd,
And now in the Duft my Body is lay'd
My whip is worn & my work It is done
And now I'm brought here to my laft home.

No-one Cares for William

Walcott, Norfolk.

William Wiseman, 1847
Here lies the body of W.W.,
He comes no more to trouble U, trouble U.
Where he's gone and how he fares
Nobody knows and nobody cares.

Is Robert Fooling us?

Robert Clarke, 1685.

But is Clarke dead? What does thou say?
His soul's alive—his body here doth lie
But in sleep until the Judgement Day,
And live he shall until Eternity.
Men say he's dead—I say so too;
And e'er a while they'll say the name of you.

A Jester's Epitaph

> Here lies the Earl of Suffolk's fool,
> Men called him DICKY PIERCE:
> His folly served to make folk laugh,
> When wit and mirth were scarce.
> Poor Dick, alas! is dead and gone—
> What signifies the cry!
> Dicky's enough are still behind,
> To laugh at by and by.

Never Trust the Honest Epitaph

Norwich Cathedral, Norfolk.

> Here lies the body of honest Tom Page,
> Who died in the 33rd year of his age.

He couldn't Trick Death

Sall, Norfolk.

> Against his will
> Here lies George Hill,
> Who from a cliff
> Fell down quite stiff.

In the early 1890's the epitaph hunter W. H. Howe visited East Anglia and recorded a 'representative selection' of East Anglian epitaphs; these he considered to be amongst the best he had seen anywhere:

> That which a Being was, what is it? shew;
> That Being which it was, it is not now;
> To be what 'tis, is not to be, you see;
> That which now is not, shall a Being be.

> As I am now, so you must be;
> Therefore, prepare to follow me:
> *Reply*
> To follow you I'm not content
> Unless I know which way you went.

> In seven years there comes a change,
> Observe and here you'll see
> On that same day come seven years
> My husband's laid by me.

> He learn'd to live, while he had Breath,
> And so he lives even in Death.

Under this Yew Tree, buried would he be,
Because his father ——he, planted this Yew Tree.

Who lived (and now is dead)
 a life prepared for dying,
Who dide (and now she lives)
 a death prepared for lyving
So well she both profest
 That she in both is blest.

In all your pride and self vain glory,
Mind this same well, MOMENTO MORI.*

*Actually this should be MEMENTO MORI . . . 'Remember that you have to die . . . ' This was
a message constantly repeated in East Anglia in the ceremonies of Ash Wednesday. The symbol
for the message (a skull on top of an hour glass) is to be found in many East Anglian graveyards (cf:
Barnington Parva, Norfolk).

My Uncle's name I have
And do enjoy his Grave;
Betwixt my Parents dear bones are lodged here.

During his tour of East Anglia, Howe made a special study of epitaphs that
had disappeared in his day but which were remembered as folk verses by the
old people of Norfolk and Suffolk. These four are from such a source:

Short and happy was my life,
But sudden was my death.
One moment talking to my friends
The next, I lost my breath.

Dear friends and companions all
Pray warning take from me
Don't venture on the ice too far
For 'twas the death of me.

His foot did slip, and he did fall.
Help, help, he cried, and that was all.

Stop, reader! I have left a world
In which there was a world to do;
Fretting and stewing to be rich—
Just such a fool as you.

On Two Undertakers from Norwich

We that have made tombs for others,
 Now here we lie:
Once we were two flourishing brothers—
 But now we die.

John Hill of Dersingham, Norfolk

Here lies I, John Hill
A man of skill.
My age was five times ten.
If I had lived till ten times ten
My like and temper would never been seen again.

Jet Propelled in Suffolk

Here lies the swift racer, so famed for his running
In spite of his boasting, his swiftness and cunning;
In leaping o'er ditches, and skipping o'er fields
Death soon overtook him, and tript up his heels.

Epitaph for a Suffolk Man Buried in an Essex Country Churchyard

Underneath this tuft doth lie
Back to back my wife and I.
Generous stranger, spare a tear,
For could she speak, I cannot hear.
Happier far than when in life,
Free from noise and free from strife.
When the last trump the air doth fill,
If she gets up then I'll lie still.

On Two Suffolk Bachelors

That I spend; I had:
That I gave: I have:
That I left; I lost.

To all my friends I bid adieu.
A more sudden death you never knew.
As I was leading the old mare to drink
She kicked and killed me in a wink.

Fond Regret

James Robinson and Ruth

Several epitaphologists attribute this epitaph to St Mary's, Haddiscoe,
Norfolk. It seems now to be lost, the wording appears in other churchyards in
the United Kingdom:

> Here lies the body of JAMES ROBINSON, and
> RUTH his wife.
> "Their warfare is accomplished"

N.B.: The quote is from *Isaiah, XL, 2*

A Bachelor's Epitaph

St Andrew, South Lopham, Norfolk.

> At threescore winters' end I died,
> A cheerless being, sole and sad,
> The nuptial knot I never tied,—
> And wish my father never had.

One Fizzy Finish

St Edmund, Southwold, Suffolk.
> Here lies the body of Margaret Crowder,
> Who died through drinking a seidlitz-powder.
> Oh! may her soul in Heaven be blessed:
> But she should have waited till it effervessed.

A Parson's Wife

Sorry were they at the death of Beatrice, wife of John Guavos, Rector of Whitacre in Norfolk:

> She was truly religious;
> Meek in apprehension;
> Expert in Geography;
> Compassionate and charitable
> Born 24th Sept, 1699, died 27th April 1740.

At Theberton, Suffolk

> I lieth Robert the Roundhead,
> Who died not by bullet but cold in the head.
> It brought me to an ague and a rheumatiz.
> Which ended me—for here I is.*

*cf: Epitaph page 35.

Philip Pilbrow, 18th January 1750, aged 101

Ixworth, Suffolk.

> There are but few that do my years exceed,
> I to the last the smallest print could read,
> I ne'er was Blooded, nor did Physick try,
> God gave me health, to him I die.

A Speedy East Anglian

Great Witchingham, Norfolk.
Thomas Alleyn's first wife Timothie, died in 1649. Speedy Tom quickly filled her place, for he himself died in 1650, and his second wife in 1652:

> Death here advantage hath of life a spie
> One husband with twoe wives at once may lie.

A Wife's Advice

St Clement, Ipswich, Suffolk.

> All women that behold me here,
> Pray for your change do you prepare;
> For in six week's time, as you may See,
> I a maid and wife and widow buried be.

Emma Quinton, aged 13

Wortham, Suffolk. 27th August 1851.

> This poor Union Child died from eating Toad
> Caps for mushrooms: which her own sister had warned her not to touch.
> She disobeyed the voice of warning Love,
> An early death, that night her very end.
> Children, obedience will ever prove
> The voice of warning is the voice of Friend.

A Rector's Wife

At Great Oakley in Essex is to be found the epitaph of the East Anglian
woman, Elizabeth Drake, whose death occurred in 1706, aged 25:

> Chief changes to man's life are known,
> Marriage and death are those we own!
> Both happened to the Rector's wife
> In two last years of her short life.
> Prepared for one as soon as t'other,
> For death as soon as came together.

To Thomas Neeve, Mercer

Framlingham Church, Suffolk.

> Here lies within the compas of this stone,
> Our Friend interr'd, and yet not be alone:
> For on each side of him a Wife doth lie
> To rest with him to all Eternitie.
>
> The first was MARY, a most Blessed wife;
> The second SARAH, not inclin'd to Strife;
> Who left behind in token of their love,
> Each one a pair most proper to the Dove.

Julia Cut Down

Oldham Churchyard, Suffolk.

> Louisa Julia dead, the thought it pains my heart.
> Alas! we live to mourn to die to part,
> And why so hasty Death, why come so soon,
> And cut Louisa Julia down, ere it was noon.

On Lady Katherine Paston, who died March 10th 1628

Paston, Norfolk.

> Can man be silent and not praises find,
> For her who lived the praise of woman kind,
> Whose outward frame was lent the world to guess
> What shapes our souls shall wear in happiness;
> Whose virtue did all ill so oversway,
> That her whole life was a communion day?

To Anne Flint

St Peter Mancroft, Norwich.

> Of Mistrys Anne Flint's Soul Jesu Mercy have,
> Which was the Dowter of *Willyam London,*
> Whos Body died and was beryed her in yis grave.
> The XI Day of *Jun* by recourse and computation
> XVC and XXIX Yer of our Lordys Incarnation.
> And to all yem yat for her thus do pray,
> JESUS grant yem Hevyn at their Dethys Day.

Thomas Windham, 1599

Felbrigge, Norfolk.

> Livest thou, Thomas? Ye'as.
> Where? With God on highe.
> Art thou not dead? Ye'as
> And here I lye.
> I that on earth did live to die
> Died for to live with Christ eternalie.

On Anne Roberts, an actress, who died in 1743

Norwich, Norfolk.

> The World's a stage, at Birth our Play's begun
> And all find Exits when their parts are done.

Mary Sandys, 1598

St Gregory, Norwich, Norfolk.

> In Heaven her soul, in me her love,
> Her body resteth here;
> Which is to God, was to the world,
> To me her husband, dear.

On the Tombstone of a Two-week-old Baby

Hamnersfield, Suffolk.

> Came in
> Looked about
> Didn't like it
> Went out.

From a Forgotten Corner

Norwich, Norfolk.

> Here lies two babbies,
> Dead as nits,
> Who died while eating cherry bits,
> They were too good to live with we,
> So God did take to live with He.

A Final Thank You

Norwich, Norfolk.

> Here lies my poor wife,
> Without bed or blankit,
> But dead as a door-nail
> God be thankit.

In Memory of Jane Ward, 1789

Parish Church, Hevingham, Norfolk.

> Here lies a maid to every good inclined,
> Loved by her neighbours, to her parents kind.
> Trusty for bliss, in Christ she's gone before,
> Changing her British for Emanuel's shore.
> Being too good to live with earthly vice,
> She's gone to feast in blooming paradise.

Regretting Andrew Broadhead

Hadleigh Church, Suffolk.

> Here lieth Andrew Broadhead
> Who died from cold caught in the head
> It brought on ague and rheumatiz
> Which ended me—for here I is.

Another Carried Off

Rineton Churchyard, Norfolk.
Fragment of a stone to a lad unknown:

> Youth was his age
> Virginity his state
> Learning his love
> Consumption his fate.

Sarah Cullam, died May 3rd 1805, aged 6 years

Wickham Market, Suffolk.

> And now, the lamp of life will burn no more,
> Her pitying neighbour does her loss deplore,
> Her parents' pride now mourning o'er her bier,
> In fond regret they shed the heart felt tear,
> They feel the loss, yet own the chast'ning rod,
> And yield in grief their daughter to her God.

Two gossiping women

There is to be found at Colton, Norfolk, a curious mural to the strange super-stition surrounding Tutivillius. This was a demon active during the enactment of liturgical prayers, or so the old folk said. He was deemed to collect in a sack the 'words omitted or syncoped by careless clergy', as well as writing down the idle words of those who joked or gossiped in church. The whole neighbourhood was known for its gossips as witness these two epitaphs.

> Here lies a gossiping woman
> No man dare deny it.

> She died in peace,
> Although she lived in quiet.
> Her husband prays, if e'er you walk this path
> Tread softly, if she stirrs she'll talk.

Sorrowing Martha

At Salhouse, Norfolk, was to be found this sorrowful epitaph:

> Martha, sorrowing, rears this marble slab
> To Benjamin, her dear, who died from eating crab.

36

A Corporal Work

Once the good parishioners of Combs, Suffolk, and Feltwell, Norfolk, enacted what was known as Corporal Works of Mercy. Taken from *Matthew, xxv,35ff.* as an inspiration, this work consisted of the giving of food to the hungry, drink to the thirsty, clothing the naked, giving hospitality to strangers, caring for the sick and tending to prisoners. To these good works was added a seventh in the twelfth century, namely burying the dead (cf. *Tobit, i,66ff*). At Combs the sentiment is expressed in glass, at Feltwell on a bench end, and the whole in an epitaph to the Suffolk itinerant goat tenders, Eliza and Mary Scrivener.

> In Eliza and her daughter
> We two within one grave do lye,
> Where we do rest together;
> Until the Lord shall us awake,
> And from the goats us sever.

An Eternal Traveller

Not far from the beautiful porch of Pulham St Mary the Virgin, Norfolk, was to be found (last seen for sure in 1893 by Rev. Wykham) this curious stone (in fragments):

FROM NORFOLK'S EARTH JOHN PALMER STARTED FOR PARADISE
12 JNE 1809.

On a Norfolk Innkeeper

> Hark! Hark ye, ancient friend! what will pass then without
> Taking notice of honest plump Jack?
> You see how't is with me, my light is burnt out,
> And they've laid me here flat on my back.

Advice to the Wise

Heed not the Voice

Blakeney, Norfolk.

> The golden gates were open,
> A kindly voice said 'Come'
> And with farewells unspoken
> He calmly entered home.

Just Enough

Norwich, Norfolk.

> Poems and Epitaphs are but stuff:
> Here lies ROBERT BURROWS, that's enough.

A Trio

Worstead Church, Norfolk.

On Women

> Censure not rashly,
> Though nature's apt to halt,
> No woman's born
> That dies without a fault.

Admonishment

> These lines are not to praise the dead,
> But to admonish those by whom they're read:
> Whatever his failings were leave them alone,
> And use thine utmost care to mend thine own.

Think Now

> Time was I stood where thou dost now,
> And viewed the dead as thou dost me;
> Ere long thou'lt be as low as I,
> And others stand and look on thee.

More Advice if you Can Bear It!

On a brass representing an emaciated figure in a sheet in Sall Church, Norfolk, dated 1454:

> Here lyth JOHN BRIGGE undir this marbil ston,
> Whos sowle our lorde ihu have mercy upon,
> For in this world worthyly he lived many a day,
> And here his bodi is berried and couched undir clay,
> Lo, frendis, see, whatever ye be, pray for me i you pray,
> As ye me see in such degree, so shall ye be another day.

Self Advice

Homersfield Churchyard, Suffolk.

> ON ROBERT CRYTOFT, OB 1810 AET 90
> As I walk'd by myself, I talk'd to myself,
> And thus myself said to me:
> Look to thyself, and take care of thyself,
> For nobody cares for thee.
> So I turn'd to myself, and I answer'd myself,
> In the self-same reverie:
> Look to thyself, or look not to thyself,
> The self-same thing will be.

Wisdom from Epigrams

The epitaph hunter, William Tegg, who was actually a printer of Pancras Lane, Cheapside, London, collected a number of epigrammatic epitaphs from East Anglia in the 1870's:

For A Clergyman

> You tell us, Clerk, 't is a sin to steal;
> We to your practice from your text appeal.
> You steal a sermon, steal a nap; and pray,
> From dull companions don't you steal away.

On Another

To the church I once went
But I grieved and I sorrow'd;
For the season was Lent
And the sermon was borrow'd.

Last Privilege

The man who first laid down the pedant rule
That love is folly, was himself the fool;
For if to life that transport you deny,
What privilege is left us—but to die?

Paying The Piper

At length, my friends, the feast of life is o'er;
I've eat sufficient—and I'll drink no more:
My night is come; I've spent a jovial day;
'T is time to part; but oh!—what is to pay?

To A Youth

Let pleasure be granted to youth:
But since human life is soon run,
And has but—to speak sober-truth—
Two moments—let wisdom have one.

Remembering a Suffolk Gardener

Yes, he is gone, and we are going all,
Like flowers we wither, and like leaves we fall;
He worked like Adam among the shrubs and trees,
And viewed his labour 'midst the humming bees.

A Rose Uncut

EMILY RICE 1886
Here lies at rest in sweet repose,
Cropt by death's hand, a bidding rose:
Beloved by all, her parents pride,
Who never grieved them till she died.

Watch your Step

Reader reflect, repent, believe, amend
Time has no length, Eternity no end.

East Anglian Knowledge

> Make me to mind Eternal things
> That when I come to die
> My soul may clap her joyful wings,
> And climb her native sky.

Victorian and Edwardian graveyards—with a few from the days of William IV—produce the one line epitaph linked with what a person did. Like:

On an author:	FINIS
On a university lecturer:	PRAEVIT ('He is gone before').
On a painter:	HERE LIES A FINISHED ARTIST
Pun on a lady's initials:	E S T : SED NON EST
On an angler:	HOOKED IT
On a miser:	GONE UNDERGROUND
On a photographer:	TAKEN FROM LIFE

An acrostic

> A m Short, O Lord, of praising thee,
> N othing I can do is right;
> N eedy and naked, poor I be,
> S hort, Lord, I am of sight;
> H ow short I am of love and grace!
> O f everything I'm short
> R enew me, then I'll follow peace
> T hrough good and bad report.

On a Gold-digger

This unusual epitaph was sent to the author by an American reader of *A Book of Epitaphs*. It purports to come from a grave in Sparta Diggings, California, of a man who had been born in Norwich:

> IN MEMORY OV JOHN SMITH WHO MET
> WIERLENT DEATH NEER THIS SPOT
> 18 hundred and 40 too. He was shot
> By his own pstill;
> It was not one of the new find
> But an ole fashioned brass barrel kind
> Such is the Kingdom ov He'ven.

41

Another from the USA

Again on an ex-patriot East Anglian:

> Farewell, dear wife! my life is past;
> I loved you while my life did last;
> Don't grieve for me, or sorrow take,
> But love my brother for my sake.

On a Young Woman

> Underneath this sod
> Lies Arabella Young
> Who on the 21st of may
> Began to hold her tongue.

A Clutch of Wayside Monuments

Remembering the shepherd-boy

There's many a cursed grave in England where there is buried one who was deemed innocent of a crime. Some mile and a half from Kentford, Suffolk—at the crossroads on the A45 road from Newmarket to Bury St Edmunds—is the grave of the shepherd-boy, who hanged himself when wrongly accused of sheep stealing.

Local stories about the grave, which is adorned with plastic flowers, are conflicting. Some say that the boy committed suicide to avoid being transported; others to avoid a public hanging. The actual reason is lost in the mists of time.

Several people record strange happenings near the grave. Owen Talbot, who used to lodge at Freckenham, Suffolk in the 1920's, remembered that every time he used to cycle past the grave, his front wheel 'would rise upwards'. To pass the grave he had to dismount and push the cycle along.

Any grave, of course, in an East Anglian cemetery where no grass grows is deemed 'cursed' by the shade of those interred within.

A suicide's memorial

It was long the practice to deny a suicide a Christian burial in consecrated ground. This custom was continued well into the 1800's in East Anglia. Records show that some churches requested of their bishop that 'a parcel of ground be saved to the north side of the church for those who take their own lives'. That piece of ground was ecclesiastically logged as unconsecrated. The reason for this was that the superstitious believed that the Devil rode in from the north and on the Day of Judgement, the souls of the suicides would form an 'occult wall of protection' for the souls of the Christian righteous buried elsewhere.

In East Anglian practice the body of the suicide was laid facing west; sometimes it was placed face downwards. Another piece of barbarous custom was prohibited by Act of Parliament in 1823, this was the practice of driving a

43

stake through the heart of the corpse, to prevent it from 'walking' in ghost form. This was an extension of the superstition attached to the treatment of the corpses of people thought to be vampires.

A traditional Norfolk site for a suicide grave lies halfway between Harleston and Redenhall church. The grave was marked by an ancient bush (now cut down) which Norfolk legend claimed had sprung from a stake driven through the heart of one Lush.

The place seems to have been used for more than one suicide's grave. Betsy Scrivener left an eye-witness account of the last burial to take place at 'Lush's Bush', as the spot was called, in 1813. The burial was of a woman who poisoned herself under the suspicion of infanticide. She wrote: 'I did creep between the legs of the men standing around the open grave in the gloom of the evening. There were six of them as custom dictated: two to dig the grave and four to lower the coffin. I saw the parish constable fix the stake in position while Mr Pryde hammered it through the dead flesh with his spade. In the gloom was Rector Oldershaw sitting on his horse, in charge of the haunting proceedings.'

The grave of Dobbs

In the parish of Kesgrave, Suffolk, is the grave of another suicide shepherd who hanged himself in a barn on the policies of Kesgrave Hall Farm. Local legend does not reveal the details of the shepherd's end, but he was called Dobbs and died around 1750.

Some time at the end of the eighteenth century, during a harvest-home supper at the Bell Inn, the story of Dobbs was being told. Many among the company disbelieved that Dobbs ever existed at all. To settle the question, some eight or ten of the roisterers made a trip to the grave there and then. The more courageous of the band set about digging at the grave and in time came across Dobbs' corpse. Before refilling the grave a man called Reeves took a tooth from Dobbs' jaw and wore it on his wristwatch until he died. Today a concrete head- and footstone mark the spot.

Searcher hint: On the A12 Ipswich-Woodbridge road pass Kesgrave church. Some twelve hundred yards further on, turn right down Dobbs' Lane, and past the row of bungalows. At a corner which turns to the right, is a pumping station, between this and the curving road is Dobbs' memorial cross-stone.

Devil's epitaphs

Despite the medieval idea that the Devil could speak fluent Latin only—priests always addressed him in such during exorcisms—and could write only symbols, East Anglian folk believed that there were one or two written epitaphs for the Devil. During a tour of Norfolk in 1819, one Mr. T.

Kelly (of 17 Paternoster Row, London), a printer, collected 'Devil's epitaphs' from the county. The collection was published in a rare pamphlet (probably used as a sales sample) in 1820. Here are a few epitaphs Kelly averred were to be found in Norfolk. Tantalisingly he did not give exact locations, but he lodged at North Walsham, and mentions Wells-next-the-Sea and Sheringham. So, he may have seen them in country churchyards in the area.

> Bad as he is, the Devil may be abus'd,
> Be falsely charg'd, and causelessly accus'd
> When men, unwilling to be blam'd above,
> Shift off the crimes on him which are their own.

Anyone being buried with this epitaph was deemed, in life, to have been a disciple of the Devil:

> After death nothing is,
> And nothing death.

In a past society which believed in Heaven and Hell as physical places, it is not strange to come across mention of an 'anti' or 'anti-devil' epitaph. Kelly claims to have found one in the Norwich area. He records it as:

> Lord of the Underworld, to thee we say,
> Thou shalt not with thee bear away
> This corpse, for at thee now
> The awful magic sign we throw. (i.e., *the cross*)

> And when thou seest the morning dawn,
> Without thy prey thou shalt be gone,
> This time there'll be no gain for thee
> And from thy power he'll be free.

In a footnote Kelly records the 'scratched epitaph' on a door at Blythburgh Church, Suffolk, said to have been etched by the Devil during a visit in 1577.

At Roos Hall, Beccles, Suffolk, is the 'Devil's footprint', to be seen on a wall, which might by some be interpreted as an 'epitaph symbol'. Some aver that the huge unmarked stone at Stone Farm, Bloxhall, is the Devil's tombstone. The stone is supposed to have been the size of a loaf of bread when first noticed in the nineteenth century; today it weighs about 51 lbs. (cf.: the East Anglian superstition that pebbles actually grow in the soil and develop into large stones.)

Curious Epitaphology

One man in particular, and several families who lived in Suffolk, were celebrated in an epitaph which was to receive immortality as a nursery rhyme:

> A frog he would a-wooing go,
> Heigh ho! says Rowley,

Whether his mother would let him or no.
With a rowley, powley, gammon and spinach,
Heigh ho! says Anthony Rowley.

At Holy Trinity, Boxted, Suffolk, is the seventeenth century effigy of Sir John Poley, famed character of the rhyme. Rowley, Poley, Bacon (Gammon) and Greene (Spinach) are all families still living in Suffolk.

An epitaph worth noting at the church of St Mary, Boxford, Suffolk, is that to Elizabeth Hyams. She was four-times widowed, and was hastened to the tomb '. . . BY A FALL, THAT BROUGHT ON MORTIFICATION . . . IN HER 113TH YEAR'.

One memorial worthy of note by the epitaph collector is that at Holy Trinity, Stow Bardolph, Norfolk, to Sarah Hare (d. 1744), as it is in wax. Those who collect epitaphs to the famous might like to note two: at Sall, Norfolk, there is the one in brass to Geoffrey Boleyn, a local farmer, whose granddaughter Anne, married Henry VIII and was mother of Queen Elizabeth I. At Oxborough, Norfolk, is the memorial of 1583 to Sir Henry Bedingfield, a governor of the Tower of London.

Index of Place Names